**36,6**

# Mirosław Bałka

# 36,6

The Renaissance Society at The University of Chicago
October 4–November 11, 1992

List Visual Arts Center, Massachusetts Institute of Technology
March 6–April 17, 1993

## Acknowledgments

*Mirosław Bałka 36,6* is the first United States museum exhibition by this Polish artist. Opening our 77th season, this exhibition represents a dialogue between the individual as represented by whole or fragmented human dimensions and the mundane materials of the real world. Bałka's work brings a direct, highly personal, and often melancholic interpretation to our audiences.

Our deepest gratitude goes first to Mirosław for so generously sharing his insights and for exposing the contexts from which the works arise. Meetings in Krefeld, Warsaw, Chicago, and Boston added immeasurably to the success and power of the project. It has been a priviledge for all of us who have had the pleasure to work with him.

We are especially grateful to the authors of the catalogue essays: Peter Schjeldahl, poet and art critic for the *Village Voice,* and Julian Heynen, German art historian and curator of the Haus Lange Museum in Krefeld. Peter Schjeldahl travelled to Warsaw and Otwock to meet with the artist and puts forth an essay which provides a context for the works' production. Julian Heynen worked closely with the artist on an extensive site-specific exhibition at the Haus Lange Museum in 1992.

Katy Kline, Director of the List Visual Arts Center at MIT, responded positively and intently to renew a collaboration with The Society and work directly with Mirosław Bałka on a new site-specific installation. I value deeply the professional relationship we have developed over the years, and admire the scholarship and personal attention Katy Kline brings to this project.

Michael Glass of Michael Glass Design, Chicago, worked with the artist in the design of the catalogue, and we are grateful to him for his longstanding commitment to our organization. Paul Baker provided careful work with typesetting and Meridian Printing provided production expertise.

Special thanks are extended to the staff of The Renaissance Society: Thomas Karr Ladd, Development Director; Joseph Scanlan, Assistant Director; Karen Reimer, Preparator; Patricia A. Scott, Bookkeeper and Secretary; and Steven Drake, Kristine Veenstra and Farida Doctor, gallery assistants. Their diligent work greatly strengthened the exhibition and this publication.

We are especially appreciative of the cooperation and generosity of gallerists Isabella Kacprzak of Cologne and Claes Nordenhake of Stockholm. They deserve special recognition for their support of the artist, and for sharing works with us. Several works were lent by the Kaiser Wilhelm Museum in Krefeld, and we are grateful to Julian Heynen for facilitating these loans.

As always, my deep appreciation and gratitude for their continuing support and trust go to the Board of Directors of The Renaissance Society. I hope the reader will take the time to look through the list of these outstanding individuals from the Chicago community who contribute so generously of their time, energy and resources. In particular we would like to thank Board member David Vitale of First Chicago Bank for coming to our aid in support of Bałka's travel to Boston. Such individual assistance is the lifeline of smaller institutions.

The Renaissance Society is especially grateful to Lot Polish Airlines for providing transportation for the artist as well as cargo. Lufthansa Airlines provided important support in cargo transportation for work coming out of Germany. With the assistance of these airlines we are able to provide our audiences with the most recent explorations within international contemporary art.

*Susanne Ghez*
Director, The Renaissance Society at The University of Chicago

White ducks in the yard of a derelict factory.

A workman with a hammer dislodges heaps of rust from an old lamppost. He seems curious to discover if, when the rust is removed, there will remain a lamppost.

Coal smoke in a powder blue sky.

"FUCK OFF" and "PUNK NOT DEAD" are prevalent graffiti. A young boy in a group of young boys, who surround him in postures of admiration, gives a passing train the finger.

Sunflowers!

Poland for an American making the first sojourn of his life to *Mitteleuropa* is a harsh place full of enchanting or disconcerting livelinesses. Understanding nothing, he collects impressions that he feels to be significant without knowing why.

Then he is in the presence of a Polish artist.

Mirosław Bałka is a big, strapping, open-faced guy thirty-four years old with a crew cut and pale blue eyes. He stands in a cramped, decrepit three-room house that seems too small for him, as if it were a playhouse or he were a giant. It is the house in which he was raised. It became his studio recently when his parents moved to a larger, nicer house next door. "Now I can't imagine how we lived here," he says. He points to the corner that contained his boyhood bed.

Bałka seeks an ashtray for his visitor, a smoker. Then he remembers that his ashtray is in Krefeld, Germany, as part of a sculpture. (A substitute is found.)

I first saw Bałka's work, having heard nothing of him, in the "Aperto" of the 1991 Venice Bienale, and I was struck by the beauty of objects exuding a sense of poverty so pronounced that it made any *arte povera* I could think of seem a deluxe commodity by comparison. What was that quality? Now having been in Poland, I begin to know: the characteristic of found material where junk is a rare category because nothing may be so wrecked or forlorn as ever to fall from the grace of possible human use. When a thing breaks irreparably in such an environment, it is freed for employment as something else. Bałka does not redeem his materials from desuetude so much as detain them from the course of twilight-dim careers in an economy of makeshift. In exhibition, his rusted metal and wizened wood seem shocked by their elegant employment, as abashed by ambient white walls and track lighting as an odd-job laborer thrust into a corporate boardroom.

Bałka leads the way to his former studio, one tiny room of a two-room shed behind the house. The other room is full of tombstones, which his father engraves when not working as an engineer in a factory. Bałka's grandfather, who died twelve years ago, was a mason who made tombstones—the local cemetery is full of his handiwork—and taught Bałka's father to engrave. Sometimes Bałka would be working, and the *chink chink chink* in the next room of his father's hammer and chisel would become maddening. He would have to flee. He credits his grandfather with making him an artist. He remembers with happiness accompanying the old man by horse-drawn wagon, taking tombstones to the graveyard. He recalls a grime-smudged album of photographs of his grandfather's tombstones, kept as a sort of catalogue for customers. The book was thrown away, and to hear Bałka describe it is to feel the painful loss of some small, soiled Library of Alexandria.

In much of Poland as in any place that has been poor for a very long time, practically no location or object is quite clean or exactly dirty—soiled seems the overall word for a physical state as various in its types of soilage as the variousness of the words for snow conditions in Eskimo languages. One might learn fine distinctions there between soil incurred from without, as "dirt," and soil generated from within, as a byproduct of decay, with terms for degrees of each and combinations of both. One might study paradox. Is dirt "dirty"? Isn't it, rather, clean: cleanly itself, clean dirt? It can be immaculate when a artist finds an artistic use for it, as when Bałka sets out a tray of ashes from the small, ancient wood stove that (very badly, he says) heated his former studio: soft gray ashes, of a subtle near iridescence, fragile as gossamer. Resting in the ashes are lumpy balls of plaster that recall for Bałka, he says, lumps of soap made by his father from salvaged slivers of nearly extinct soap bars.

Bałka's materials teeter between the forms of their past and possible uses and the entropy of their decay, their molecular disintegration. I think again of a functioning lamppost that is either rusted or made of rust. The workman's hammer that will discover the truth about the lamppost may be a symbol of a new Poland. So, too, may be the work of Bałka, an artist internationally resonant who says he is happy to keep working in the old Warsaw suburb where he grew up (while living in another, nearby area). The suburb, Otwock, figures in the early writing of Isaac Bashevis Singer. It was the last stop on a famous tram line from Warsaw and site of fashionable tuberculosis sanitariums. It is haunted by Poland's demolished bourgeois and Jewish pasts. In the much-vandalized Jewish cemetery of Otwock the sandy soil, long scavenged of sand for making cement, fails to cover protruding human bones. Bałka's studio feels close to the center of a world anxiously contemplating questions of the persistence and possible transformation—destruction or redemption—of the human. It is something a visitor thinks about in Poland.

In last summer's Documenta IX Bałka showed a work incorporating stones from the grave that his grandfather planned for himself. The stones are terrazzo (pebbled cement ground to flat surfaces), poor people's marble. The family, having become relatively prosperous, deemed the material too humble. Bałka's grandfather lies beneath granite. The grandson keeps faith with the grandfather, who in spirit follows his rejected sepulcher around the world.

"Something happens for you in your childhood, so strong for you that it never changes," Bałka says. The minimalistic vocabulary and syntax of forms he has adopted—lingua franca of the world of international sculptural exhibition in which he is a rising star—is "just the visual aspect," he explains. An obviously Joseph Beuys-influenced lexicon of metaphoric materials (fleshy foam rubber, for instance, and salt for the primal human body) might similarly be termed just the semiotic aspect of Bałka's art. (Another of Bałka's Western affinities is to early Bruce Nauman, whom he recalls in taking a severe, ad hoc approach to what might be termed the problem of bootstrapping art: You are an artist in your studio, alone in space and adrift in time. Now what? Look around. What's there? What can be done with it?) Bałka is not yet an innovator in sculptural aesthetics or poetics. He is prepossessing for his ability to make a learned language tell his story. The virtue of the language for him seems its capacity to sublimate—to render subliminal—charges of feeling otherwise uncontrollably powerful and contradictory.

Bałka told me that in 1986, while still in school, he traded a bottle of vodka to a man with a broken nose for a small, crude figurine of Santa Claus that had a broken nose. For one of his first shows after graduating from the academy, he arrayed many plaster casts of this pathetic object facing a pyramid of snow into which a rope descended. When the snow melted, the original Santa was revealed hanging by its neck. A lynching? "Yes, that is the word," Bałka said. For another performance-like piece, he displayed a big rabbit made of used fabric surrounded, and apparently threatened, by many sharp-toothed steel jaws, painted white. On consideration, Bałka cut out for the rabbit a sharp-toothed mouth of its own for self-defense. The two installations seem self-explanatory as parables of the artist in an onerous world. I asked him how those startling works were received. "Fine," he said. "Nobody treated them as art."

Bałka credits as a formative experience his reading, in English, of James Joyce's *A Portrait of the Artist as a Young Man*. The book encouraged him to embrace his simplest and often most abject early experiences as themes for art. He was transfixed by Joyce's account of the sensation of bedwetting: first warm, then cold. He made a sculpture about it. Two rusted pipes close together and upright against a wall stop at eye level. They are filled, Bałka fancies, with tears. Short sections of pipe set in the floor are for him positive forms of the negative spaces made by the act, mysteriously satisfying to a boy, of pissing in snow.

In Warsaw I saw a sculpture by Bałka in a Polish virtual shrine of contemporary art, the Galeria Foksal in the complex of an old villa used by the Polish Association of Architects. The Foksal consists of an office and a very small exhibition space with lovely oblong proportions, as if it were the scale model for a substantial gallery—and as if it were a pocket-sized working miniaturization of the panoply of a free international art world that until recently could gain no more purchase in Poland than this cherishable toehold. Memorable exhibitions have been held there of local and Western art (Giovanni Anselmo, Lawrence Weiner, Arnulf Rainer, Joseph Beuys, Tony Cragg, Anselm Kiefer) in the gallery's difficult history since 1966. Its director for all that time, Wiesław Borowski, is a tough sort of aesthete-saint who couches his passion in watchful, shrewd deference. Censors used to preview all of Borowski's shows. Polish censorship wasn't so bad, he told me with a shrug: if the censors couldn't understand the art, they figured it was no threat and let it go. (The opposite policy pertained in Czechoslovakia, he said.) In the gallery when I visited was a Bałka that incorporated a low-lying, narrow, rusted-steel trough, triangular in cross section, holding a rivulet of dried salt. The trough was body-length, which make it a large object in the little space. But if one imagined it as a body lying down, then its situation seemed capacious, as if it were saying, "See, there's lots of room for me here." All of Bałka's work, one way or another, may say something similar, intent on finding the minimum requirement of space and time in which *to be.*

Bałka's world is wide now. So is Poland's, though in a country that needs practically everything in the way of infrastructure and whose currency features a million zlotys note (worth eighty-some dollars last summer) the extent of the freedom rather dwarfs immediate prospects for making effective use of it. With Bałka and his fiancée (now wife), artist Zuzanna Janin, I ate carp at a cozy restaurant in the Old Town section of Warsaw, the Renaissance district which, destroyed like most of the central city in World War II, has been painstakingly rebuilt to its original appearance. The effect of the restoration is a bit Disneylandish, but promising in its energy. After dinner we sat at a cafe table in the night in the main square, and I liked being there with Mirosław and Zuzanna, watching them watch the passing scene. Their scene.

We in the American art world have waited for something from the former Soviet empire, something new. Our eagerness for creativity from that quarter seems partly an expression of healthy curiosity and goodwill, partly a confession that our own artistic resources feel exhausted and in need of exotic transfusion. The pickings so far have been slim, and the best of them—as by Ilya Kabakov, as by Bałka—tell us why. They also teach us how to square our expectations with what we are likely to receive. An "Eastern" artist must first master an artistic idiom of the West, because none of any sophistication, with a local accent, survived the long darkness. Then the artist must speak in that alien idiom of painful things, telling as with a stammering tongue, unused to speaking, of so many truths so long unspoken that they have sedimented like a river bottom. Only when all the layers of silence are dredged may we encounter the "new" in our frenetic Western sense.

Bałka showed me an incredibly dilapidated old public trash container he discovered in Germany, an image of which he used as a poster for the exhibition in Krefeld. He had been very nervous about the show, he said. "But when I found this, I knew it would be all right." In Germanic lettering beneath the container's gaping mouth is the hungry, peremptory plea,

*"Bitte"*

Peter Schjeldahl

**Thresholds**

As far back as 1985, presented with the piece entitled *Memory of the First Holy Communion*, there was this moment: of approaching and being stopped in one's tracks. Before having a chance to explore the object, to contemplate the work according to well-practiced conventions, there is a threshold and it demands attention. It interrupts the expansive stride that otherwise would take in and conquer the object unhindered. For a moment, it arouses awareness that one territory is ceding to another, that one is stepping into a new space — someone else's space. In that early work it is the actual entry into a house, the change from the light of day into the dark of the rooms, a greeting and a guest's gift that make this threshold a part of the whole. Then, later, it is little wooden boards framed and carefully placed or, as in this show, those metal plates on carpet or felt underlays that both announce and guard that which is to come. Like guardians and tokens of presence, these are the first things to lie in the viewer's path. These thresholds are both invitation and boundary mark, link and dividing line. Unassuming as they are, they do influence the rhythm of one's approach. Should one walk around them or simply step across? Or do they, as steps, lock the body into the sculptural construction, the structure of the space? As crude and fit for utility and the tread of feet as they may seem, they do not really invite such action. They are far too self-contained, even self-sufficient for that. Any actual step onto this platform would mean a proximity that, while it could evoke a marked physical reaction, would amount to an impropriety. It would be a transgression of intimacy.

Invitation and demarcation; the quality of transition, of brief sojourn; an element of establishing contact; an introduction — the thresholds are, in fact, like the title of the Krefeld exhibition: *bitte* (please). That, too, lay in a zone between invitation and question, offering participation and, in its hesitant aspect, pleading care in the encounter.

**Zones of shelter**

Along a wall, pushed into a corner, in the lee of a wall projection, these are the sites of such sculptures. No far-reaching, thematically intertwined relations are set up between the art and the architecture. It is rather as zones of shelter that the pieces seek out whatever peripheral locations the building offers them. They, the pieces, do not retreat entirely into these recesses as if they had to fear the open spaces and had not been made for them; they do not depend on the architecture or, to put it another way, they do not rely on the architectural context as a means, for example, of pointing out the significance of context at all and the fragile status of the work of art in the age of modernity. Their proximity to the fixed boundaries of their environment is more a precautionary measure. These zones offer protection from two things: they preserve the sculptures from all too rigid a force, which they could emanate if they were set up as freestanding monuments center stage, and they divert the viewer's all too easily elicited submission to the seductive charms of simplicity and any potential symbolism. As it is, the pieces are encountered in these sites just as things can be encountered half by chance, half by surprise in life generally, prompting unimposing questions to which one will return nonetheless because, quite unexpectedly, one glance has not settled everything. These zones of shelter blur the status of the pieces in them, drawing them into a productive doubt.

**Steel**

Unlike the figures modeled in cement or old construction timbers, the steel of the more recent work to a large extent remains mute. It is not so loquacious with stories of human beings or their traces. Its very material character is harder, less accessible. It comes from less gentle times; machines produced it and in large amounts, not hands and simple tools. It bears with it that of the city and anonymity — not the country, the comprehensible, individuality. To work it requires more

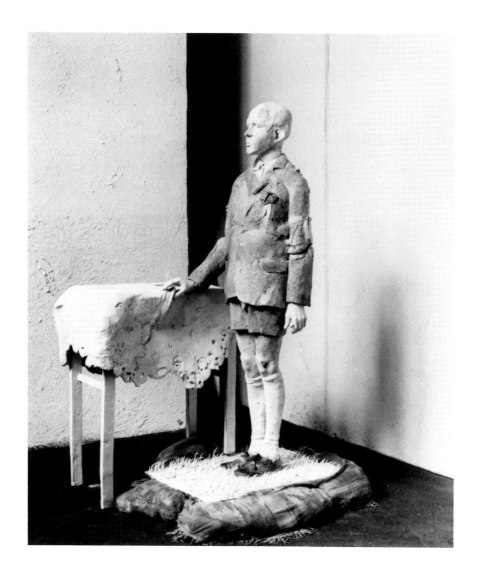

"Remembrance of the First Holy Communion," 1985, colored cement, fired clay, wood, pin cushion, 69 inches high, collection of the Muzeum Sztuki, Łódź

muscle, more equipment. Its edges are sharp. Injury is possible. Yet time has been quick to leave its traces here, too, in scratches, marks, dirt, and rust.

But its most salient quality in these works is that it is much more abstract than the wood which preceded it. Just as sculptures made of it are far less vividly reminiscent of certain objects, the material itself is more removed from the potential of romanticism that can be associated with wood. Like wood, steel does not deny either its origins or the possibility of being a vehicle for meaning. But it limits the field of associations and channels it more austerely towards a few, possibly final questions.

**Terrazzo**
As presented here, terrazzo denies its richer heritage. Patterned in black and white, mixed in small components so that the overall effect is ultimately one of blandest gray, it is evidently a substitute material. A whiff of the dignity of limited circumstances hangs in the air. But as the material of these sculptures it withholds its qualities even more. For although the slabs rest on their metal stands they have been flipped over, plain side up — as if a gravestone had been toppled and set up again upside-down. Only the edges give the material away.

Its scope thus reduced, the terrazzo is exploited all the more through a particular feature, namely its weight. The slabs seem immovable. Where in earlier pieces foam rubber or salt or water "rested" upon the stands, such "beds" now become "graves." Within them forces are fixed and sealed. Only at the edges or in small, accompanying details, like gifts, is there any hint of what is enclosed.

**Felt / carpet / foam rubber**
We enter the house, the apartment, that which is one's constant surroundings, one's second skin, the accustomed routine. It is full of things one needs and yet does not see, and which multiply and age. Layers of felt, carpets, and foam rubber shield this domesticity from cold and noise, making it soft, enwrapping it, isolating the Here, the Inside, the Mine from that which is There, Outside, the Other. To be more precise, they are materials for sites of transit, those zones where disparate things touch, points of contact between body and environment. Their function as mediators and protective layers remains operative in these works. No metal rests directly on the ground; under every threshold a piece of carpet has been laid, and every leg of steel is isolated from the ground by a patch of felt. This careful provision is the rule.

The significance of these materials, though, is that they quickly assume the traces of use, storing wear and tear as "dirt." The warmth, quiet, and indeed beauty that they provide come at the expense of their limited durability in the face of life. This soon renders them objects with a history. But their intact appearance and their use fade at different rates. What has been given up at one location because it seemed to confront the senses with too intense a recollection can still be useful somewhere else.

**Salt**
It collects in little recesses, along a joint, at the bottom of a suspended sack. It appears but discretely, very discretely in these sculptures as a kind of addition, but one whose very consistency and color distinguish it from the rest. Among the materials contributing to the pieces, only salt is true white, that is, pure. Even when such inclusions are no bigger than droplets, they draw one's attention more than any chance mark in their vicinity. These must be drops of a very special kind. The substance retained within prompts questions, demanding examination since it does not automatically reveal its nature. The attentive placing of this material, its evanescent, chemical quality recalls ingredients which otherwise play a part in ritual actions. What could it be a symbol of?

Salt is a substance needed for life, and its occurrence (be it ever so marginal in these pieces) introduces a further mark of life in its existential, physical aspects. Salt, too, is the desiccated

16

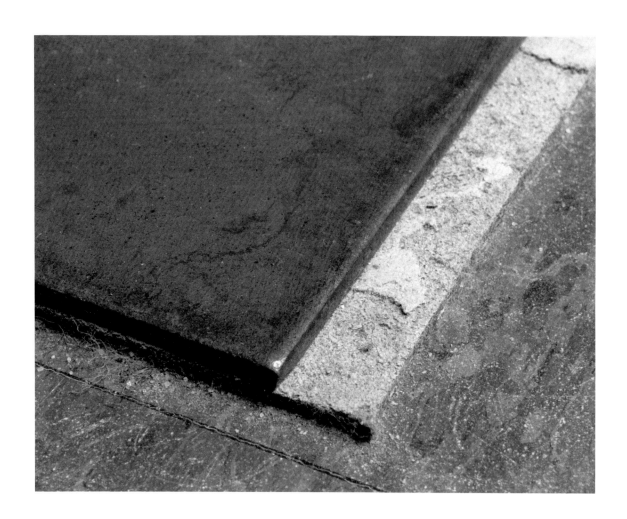

residue of need in life—sweat and tears. In these works it is used only with great care, in small doses reduced to point and line. It has relinquished the illustrative role it had in earlier pieces, covering a whole bed as night fear. It has become a precise, condensed token.

## Ash

Again, residue: of something that once was, once lived. Sometimes it can hardly be distinguished from dust, the color just as light, the weight just as little, as easily dispersed in all directions. Ash has a hard time bearing all that transience attached to it like a nickname that will not go away. Ash and death are spoken of in a single breath, and handling the former is a proportionately risky business. It takes one readily into the all too evident, the banal, the tautological. Its application must be as considered as the way in which it is kept and strewn: like the small quantity of ash gathered onto that little tin lid that lies before a large, closed metal box. Elsewhere the same material fills the incisions in two stone slabs, almost indiscernibly gray on gray. As for the cut-outs, they stand close by in their own right, as squat as sills. Then again, ash as the finest dust has trickled from a large, dark cloth sack, visible only for those who look closely and are inclined to see links.

For all the care in handling it, the ash remains final material, the substance that remains when all is spent. Wherever it blows in, it recalls the simplest, surest, gravest thing, death. Thus ash here is also a distillation of the other substance, salt. Needs of life, need of life, present but not ruling over all.

## Proportions/body

The titles are the proportions and in these proportions is the body. One hundred ninety is the height of the artist in centimeters. His body, standing here for all, could be lying on the slabs or in the boxes or standing in the enclosures. The carpet "pictures" on the wall have his proportions, the mouths of two cloth sacks are based on his chest measurement, and the "tent" is just that much bigger so that it might afford the body shelter. Where the proportions widen (as in the large sack), there would be room for two. Standing in front of the vertical chambers, one will soon understand them as instruments for the body. Their very proportions appeal to it like an apparatus serving its needs. One chamber is based on the pattern of a shower, the other offers a seat and a drain. But like the thresholds, there is nothing here to invite real, practical use. The proportions in the sculptures do not beg to be evaluated in direct relation with one's own body; the eye, experience, and memory suffice.

The proportions of the works link them decidedly to the human figure, not by depicting it but by respecting the dimensions that are peculiarly mankind's. No piece is so significantly larger than human as to dominate. The objects are within reach of the human body, more partner than simply something other, however full of questions individual pieces may be. To take up that proportion and maintain it means to take up contact and establish links. In the proportions there lies something like a trust that sculptures can still be an interlocutor, a response to the viewer as a body and a person.

## Open/closed, empty/filled

are pairs of opposites that accompany the works in the exhibition space as they unfold, like a rhythm emerging and submerging repeatedly. The steel plates, leaned against each other and recalling a rudimentary canvas cover, shelter nothing. The joints with the ground are sealed with salt, but the situation's air is one of abandonment. The view passes straight through into nothingness. Immediately adjoining, however, a metal container—evidently a garbage can filled to the brim, neatly, with plaster—is fullness pure and simple, a body filling its skin, as it were, down to the last crease. A little farther on stand another two such containers, but these are empty apart from a layer of foam rubber at the base. In other pieces, not placed side by side, it is memory that brings opposites together. Where some of the flat steel stands support heavy terrazzo slabs, others have none.

The inflections developing in formal/sculptural juxtaposition as one wanders through the oeuvre could be read as a constant alternation of presence and absence. Container and contents, shell

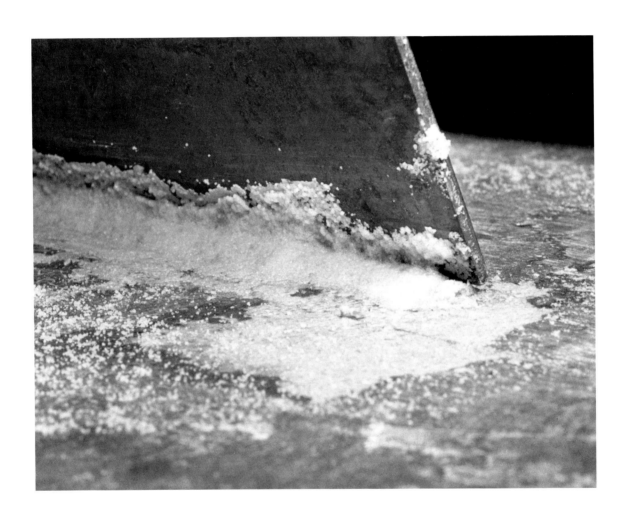

and nucleus, skin and flesh, body and individual are implied as an integral unity, but one always in danger of disintegrating. This is strikingly exemplified in a piece where an empty box and an empty stand, of human proportions and reduced to the barest lines, are proffered, and one is suddenly aware how, on entering the space, standing at the threshold, one's own body could be the missing part.

**Spouts/drains**

In many of these simple boxes, containers and shells that seem to rely so tacitly on the rhetoric of their austere form, the discerning eye soon falls upon small details. In both bases and lids there are tiny holes, sometimes grouted with foam rubber, ash, or salt, sometimes left vacant. Their effect is that of those barely perceptible but useful gadgets on practical implements, the purpose of which only becomes apparent after a long time in unusual or extreme kinds of application. These holes are only the size of a drop of liquid and it would be for liquids that they could serve as spouts and drains. One of the vertical sculptures demonstrates their significance in fair detail and narrative style. Like a final drop, a pellet of foam rubber still hangs above in its entrance hole. Below, on an intermediate platform, several such holes are arranged into a kind of drain; here, too, as if just about still held up by the surface tension, another droplet.

More cryptic are the short, thin brass tubes rising from the bodies of metal at various points. Inclined at acute angles, they both emphasize their function and provoke the question as to what on earth should flow in or out of them. Is it from this sealed box that the ash has escaped by this route to be gathered upon the little lid before it on the ground? At other points, on top, nearer the viewer's head, these cannulas appear as pairs, next to one another with only a little space in-between. Their pointed ends dissuade one from practical comparison, but are they not the same distance apart as one's own nostrils, implying perhaps the purpose of venting gases or smells which beg the taking up, guessing at, and remembering?

What lends the spouts and drains significance is the quality of these containers of responding to the human figure. As sober and cool as they are in construction, as little as they impose their presence, they do direct the senses to certain specific and complex compounds, namely the juices and smells of the body where thoughts are sluiced quickly to extremes: to excretion, sickness, decay, and also love.

**Speech**

Mirosław Bałka occasionally refers to his pieces as sentences. This is to suggest that they form into complete statements while consisting of a fabric of diverse elements, like words. These words and, earlier still, the letters—in other words the materials and individual components—are the prime source. Within them all is contained, as in a dictionary. The mind already sees the connections between them as well—but as intention and anticipation only, in the conditional. What has already entered into appropriate relations in the infinitely dense and manifold realm of the mind has yet to become body and sculpture in the real space of the exhibition. So it is here that the sentences first develop, not in dependence but in a partnership with the space. Sometimes the pieces/sentences have a definite beginning, but what is more important for the artist is that they can be seen to conclude, finding their close vis-à-vis some other situation, another sentence. This is not to say that every piece can be taken in at a glance. Some are more extended and unfold through several areas.

Finally the sentences link to form the articulation, the speech of the exhibition. It is not necessarily a linear text; it should create an overall space which does not contradict the individual sentences/sculptures. It may include some asides, as if not all is intended for all (think only of the black tooth made of chewing gum in Chicago, but not exhibited). Just as source materials and single components are integrated in the work, so the works themselves should find their natural place in the exhibition. A place of this kind is valid for a certain time. Thereafter the sentences will have to find spaces in other speech without forfeiting their essence.

**Limitation / care / construction**

The limitations of the world in question are self-evident: simple, "poor," old materials, simple ways of joining objects together, a reticent presentation in the exhibition space. Some elements are so reduced, so mute that a first encounter leaves one guessing whether they are good for anything at all or are only the relics of an aimless experiment. What these humble relationships are not is picturesque. Their austerity with its bitter aftertaste—and in the new work, the hardness of the sculptures—are enough to prevent that. There is no unfathomed expanse of a plethora of relics and ruins, either. The work of clearing up and sweeping already seems to have been done. The point now is to find a meaningful arrangement of life.

One becomes accustomed gradually to the limitations and discovers their potential, becomes aware of what has already been achieved. If these simple objects and images speak of great austerity, they also emanate a brilliant and unclouded pitilessness. They operate with what they have and for all the limitations are not wanting, since they have the possibility of concentrating on essentials. Suddenly the amount of care and attention that can be found here, on the other side of ruthlessness, is plain. Much sensitive care goes into the collection and depositing of these things. Nothing is left to chance and no combination is forced. Again and again, the little white pads of felt vividly come to mind — those minimal yet highly significant insulators that embody dramatically the resting of heavy bodies of metal on the ground. Rudimentary and restricted as the edifice seems, the prevalent feeling from the core is that of care and devotion to the work. Doubtless it must be a person with commitment who is installing something here for a further life. That could be the general heading: Options in (re)constructing a real life.*

Julian Heynen

*It has not been mentioned so far, but those who would interpret these pieces against the backdrop of a country and a society and an ideology in ruins and liberated are probably not in the wrong. Nor are those, probably, who see our own fascination at that phenomenon against the backdrop of a different freedom and a different decay. But the work will not be reduced to that. It is there.

*This is a slightly edited version of an essay first published in the exhibition catalogue for Mirosław Bałka at the Museum Haus Lange, Krefeld, Germany, 1992. Translated from the German by Stephen Reader.*

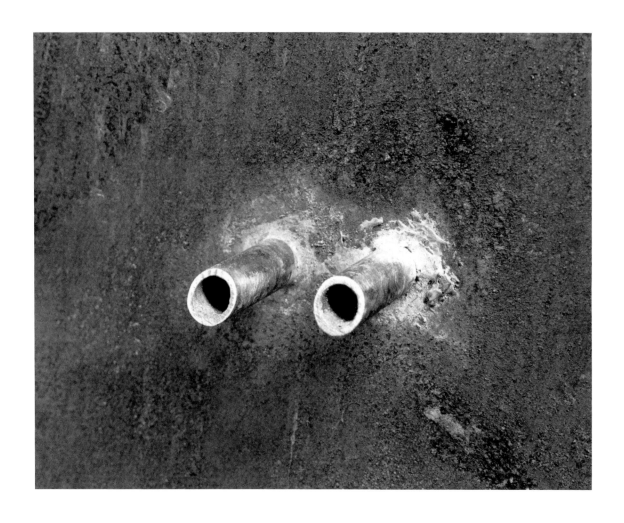

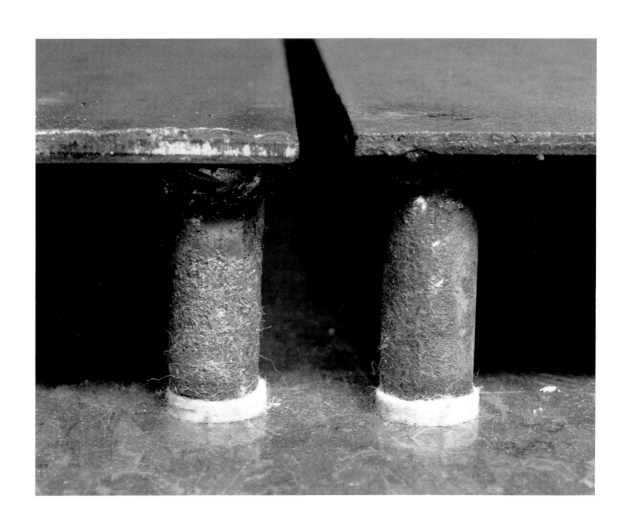

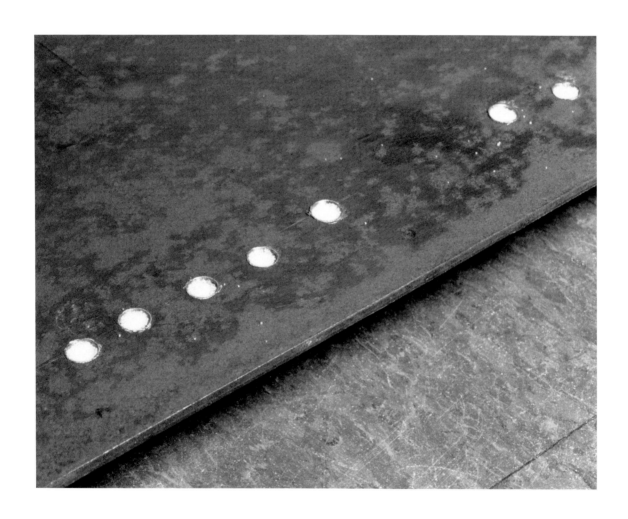

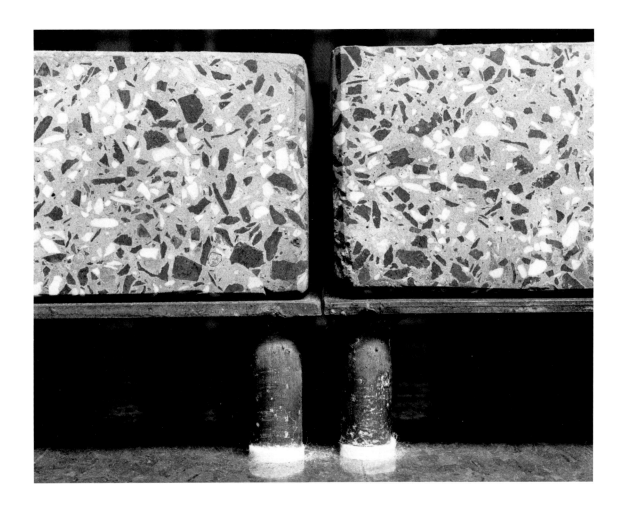

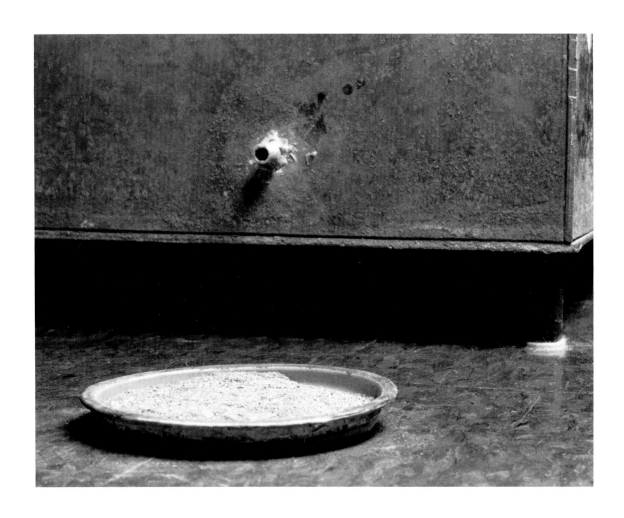

**Exhibition List**

The titles of works refer to their components' dimensions in centimeters.
The Ø symbol denotes diameter.

1.
"41 x 31 x 1, 190 x 60 x 54"
1992
Steel, earth, electric blanket, felt
Lent by the artist courtesy of Galerie Nordenhake, Stockholm

2.
"190 x 60 x 4, 190 x 60 x 4, 190 x 50 x 40, 190 x 50 x 40, 190 x 50 x 40, 50 x 40 x 1"
1992
Steel, carpet, foam, brass, salt, ash, felt
Lent by the artist courtesy of Galerie Nordenhake, Stockholm

3.
"30 x 40 x 1, 30 x 40 x 1, 190 x 60 x 1, 190 x 60 x 1, 40 x 30 x 11, 40 x 30 x 11, 190 x 60 x 11, 190 x 60 x 11"
1992
Steel, terrazzo, sand, foam, ash, felt
Lent by the artist courtesy of Galerie Nordenhake, Stockholm

4.
"40 x 30 x 1, Ø26 x 39, Ø26 x 39, 200 x 90 x 87, 190 x 30 x 44, 190 x 30 x 44, Ø26 x 39"
1992
Steel, plaster, foam, carpet, salt, salt water
Lent by the artist courtesy of Galerie Isabella Kacprzak, Cologne

5.
"Ø7, 5 x 26, 5, Ø7, 5 x 26, 5, Ø6 x 26, 5"
1991
Steel, ash, salt
Lent by the artist courtesy of Galerie Isabella Kacprzak, Cologne

6.
"40 x 30 x 1, 217 x 87 x 39, 191 x 57 x 37, 191 x 57 x 37"
1992
Steel, fabric, carpet, salt, ash
Lent by the Kaiser Wilhelm Museum, Krefeld, Germany

7.
"190 x 60 x 54, Ø9 x 1"
1992
Steel, brass, ash, felt
Lent by the Kaiser Wilhelm Museum, Krefeld, Germany

**The Installation**

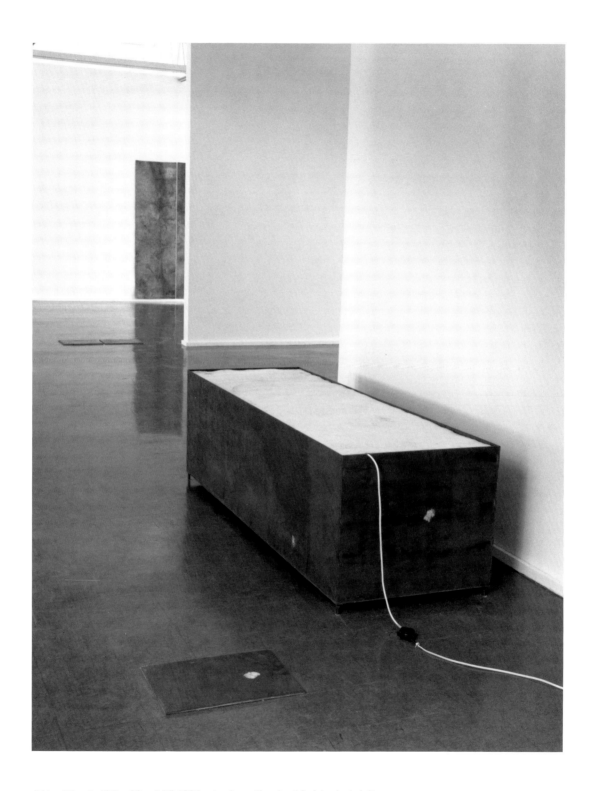

"41 x 31 x 1, 190 x 60 x 54," 1992, steel, earth, electric blanket, felt

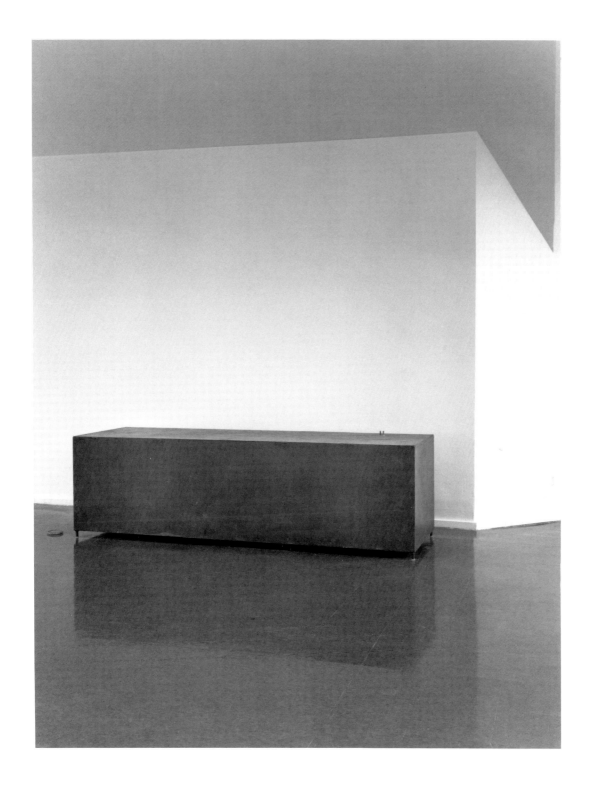

"190 x 60 x 54, Ø9 x 1," 1992, steel, brass, ash, felt

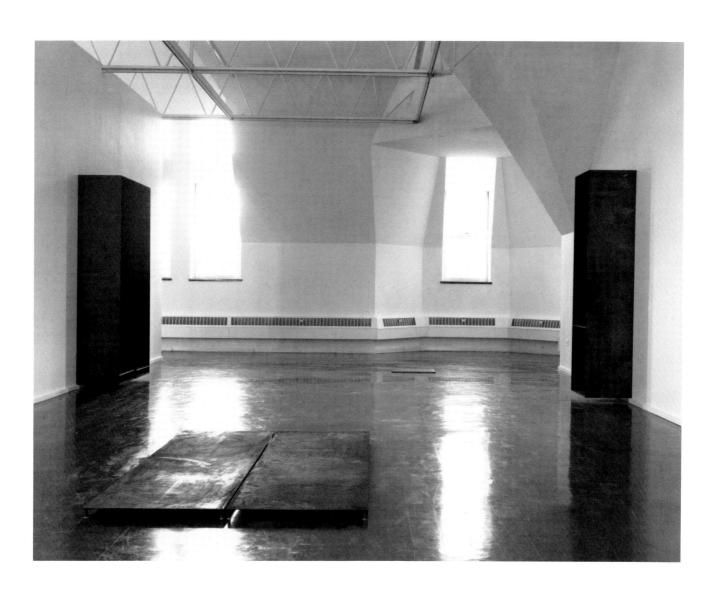

"190 x 60 x 4, 190 x 60 x 4, 190 x 50 x 40, 190 x 50, x 40, 190 x 50 x 40, 50 x 40 x 1," 1992, steel, carpet, foam, brass, salt, ash, felt

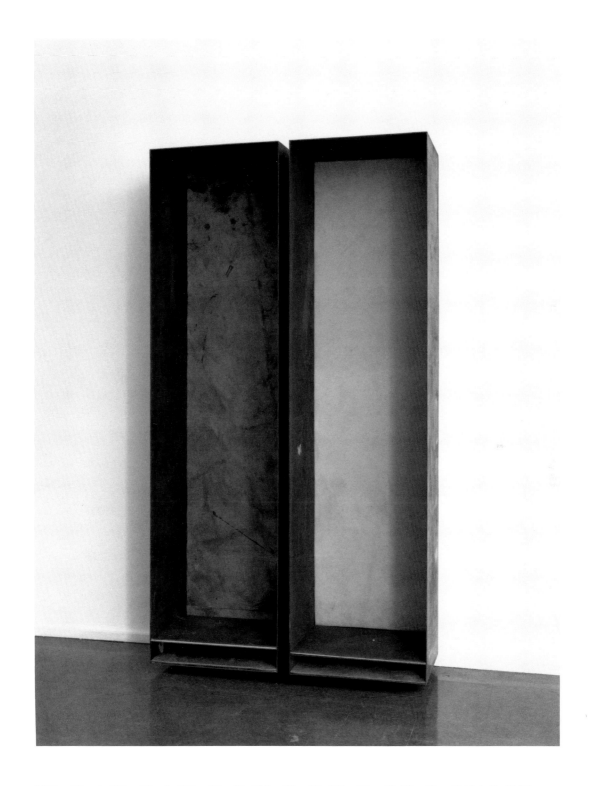

"190 x 60 x 4, 190 x 60 x 4, 190 x 50 x 40, 190 x 50 x 40, 190 x 50 x 40, 50 x 40 x 1" (detail), 1992, steel, carpet, foam, brass, salt, ash, felt

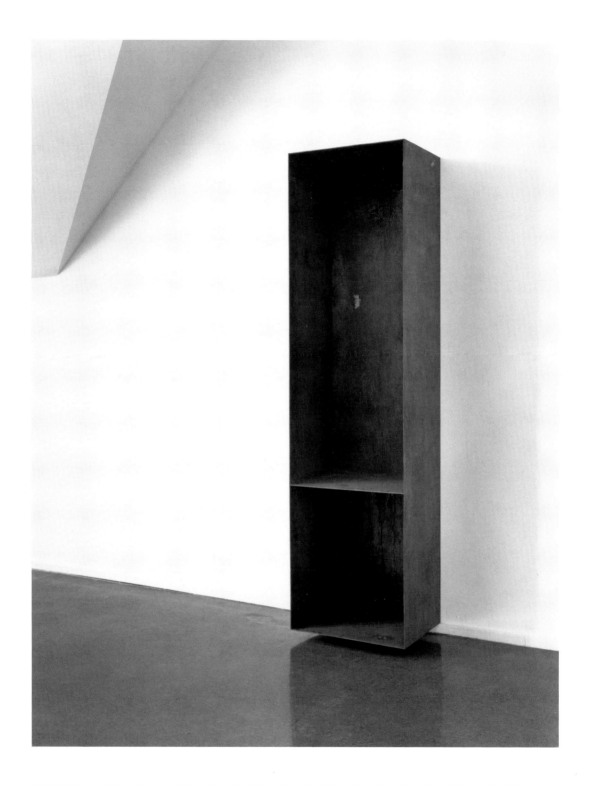

"190 x 60 x 4, 190 x 60 x 4, 190 x 50 x 40, 190 x 50 x 40, 190 x 50 x 40, 50 x 40 x 1" (detail), 1992, steel, carpet, foam, brass, salt, ash, felt

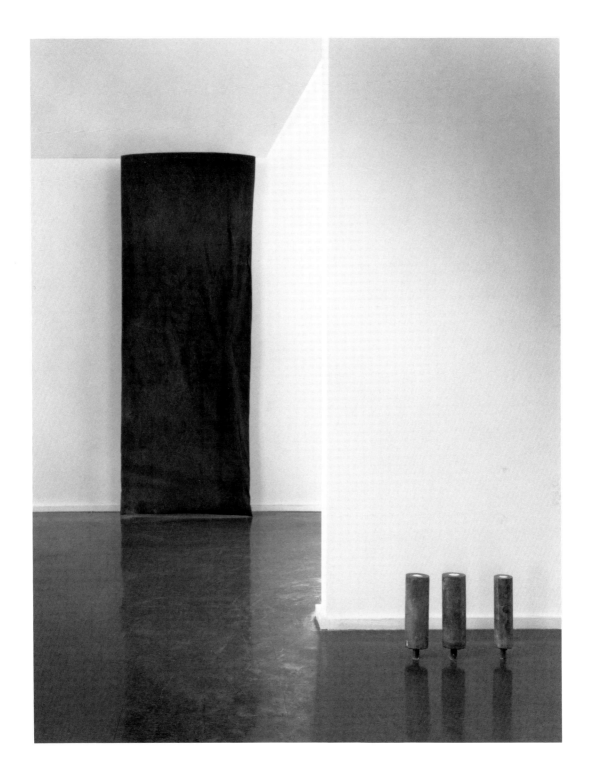

Left: "40 x 30 x 1, 217 x 87 x 39, 191 x 57 x 37, 191 x 57 x 37" (detail), 1992, steel, fabric, carpet, salt, ash
Right: "Ø7, 5 x 26, 5, Ø7, 5 x 26, 5, Ø6 x 26, 5," 1991, steel, ash, salt

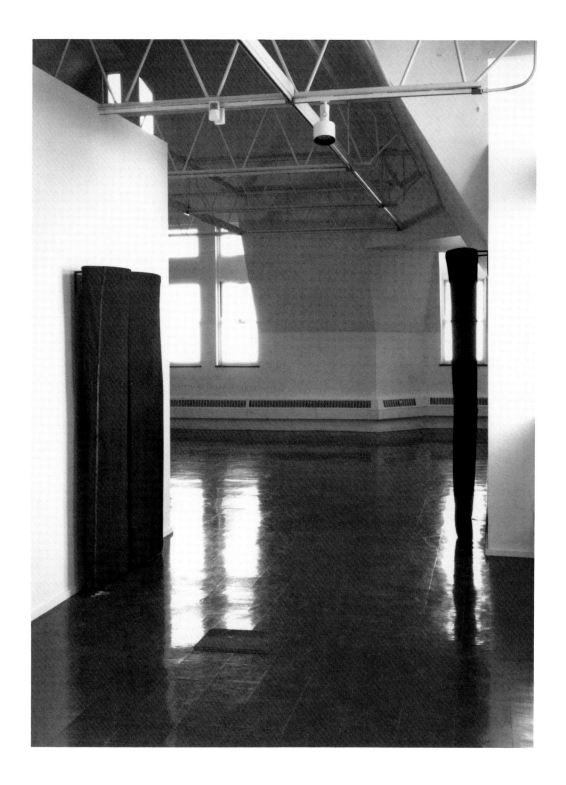

"40 x 30 x 1, 217 x 87 x 39, 191 x 57 x 37, 191 x 57 x 37," 1992, steel, fabric, carpet, salt, ash

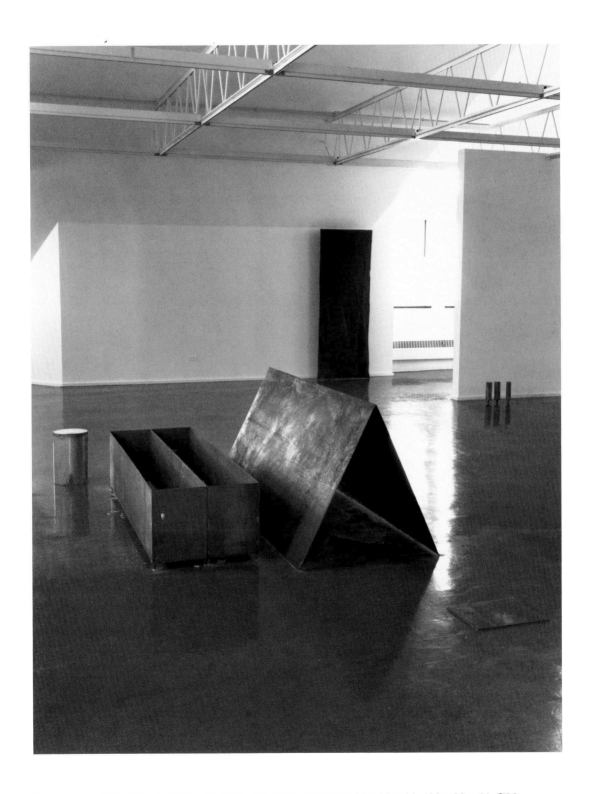

Foreground: "40 x 30 x 1, Ø26 x 39, Ø26 x 39, 200 x 90 x 87, 190 x 30 x 44, 190 x 30 x 44, Ø26 x 39" (detail), 1992, steel, plaster, foam, carpet, salt, salt water. Background left: "40 x 30 x 1, 217 x 87 x 39, 191 x 57 x 37, 191 x 57 x 37" (detail), 1992, steel, fabric, carpet, salt, ash. Background right: "Ø7, 5 x 26, 5, Ø7, 5 x 26, 5, Ø6 x 26, 5," 1991, steel, ash, salt

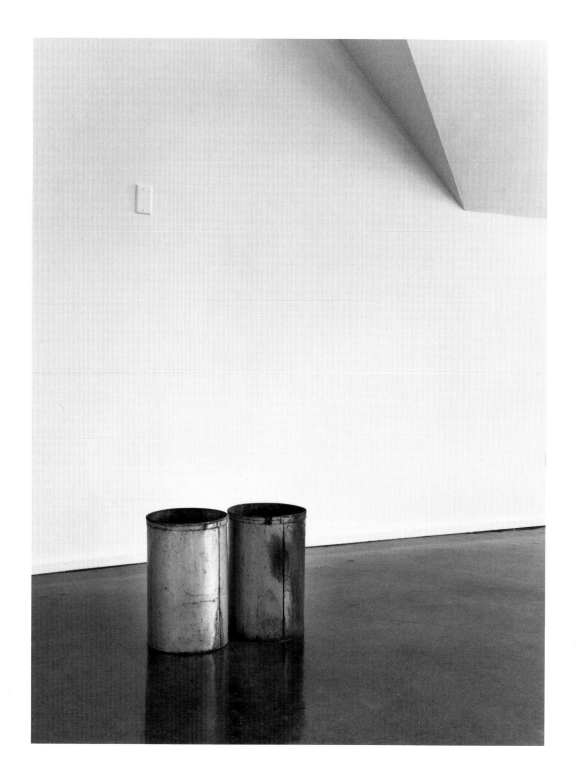

"40 x 30 x 1, Ø26 x 39, Ø26 x 39, 200 x 90 x 87, 190 x 30 x 44, 190 x 30 x 44, Ø26 x 39" (detail), 1992, steel, plaster, foam, carpet, salt, salt water

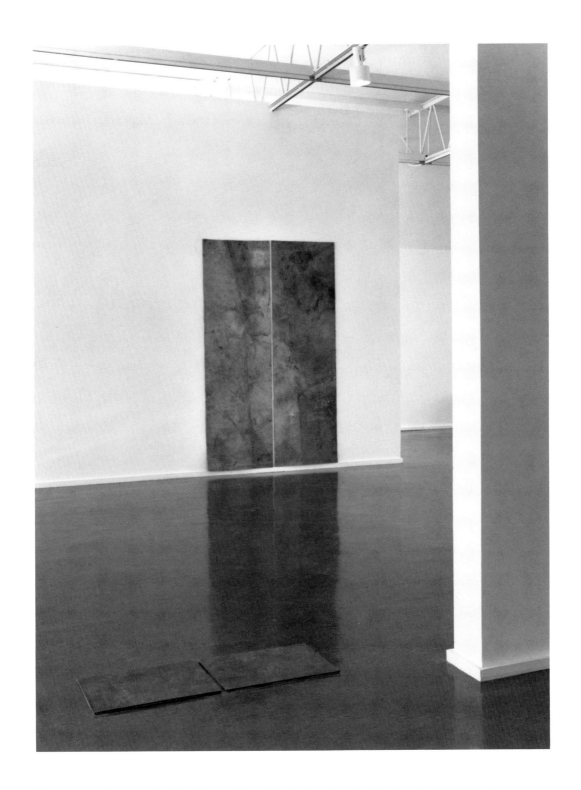

"30 x 40 x 1, 30 x 40 x 1, 190 x 60 x 1, 190 x 60 x 1, 40 x 30 x 11, 40 x 30 x 11, 190 x 60 x 11, 190 x 60 x 11" (detail), 1992, steel, terrazzo, sand, foam, ash, felt

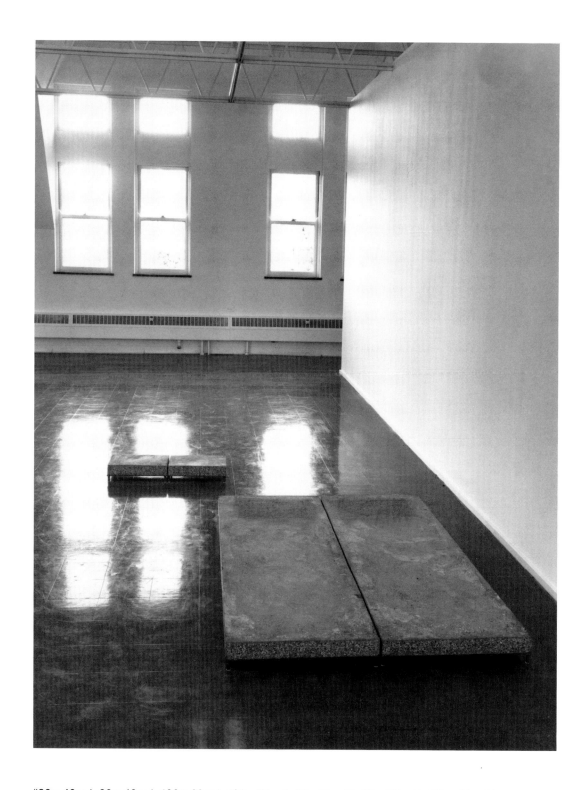

"30 x 40 x 1, 30 x 40 x 1, 190 x 60 x 1, 190 x 60 x 1, 40 x 30 x 11, 40 x 30 x 11, 190 x 60 x 11, 190 x 60 x 11" (detail), 1992, steel, terrazzo, sand, foam, ash, felt

# Mirosław Bałka

Born in Warsaw, Poland, 1958
Works in Otwock, Poland

## One-person Exhibitions

1992
*No Body,* Galerie Peter Pakesch, Vienna
*bitte,* Museum Haus Lange, Krefeld, Germany
(catalogue)

1991
———, De Appel Foundation, Amsterdam
(catalogue)
*April/My body cannot do everything I ask for,*
Galerie Foksal, Warsaw (catalogue)
*IV/IX My body cannot do everything I ask for,*
Galerie Isabella Kacprzak, Cologne
*XI/My body cannot do everything I ask for,*
Burnett Miller Gallery, Los Angeles

1990
*Good God,* Galeria Dziekanka, Warsaw
(catalogue)
———, Galerie Nordenhake, Stockholm

1989
*River,* Galeria Labirynt 2, Lublin, Poland
(catalogue)

1986
*Percepta Patris Mei Servivi Semper,* Galeria
Pokaz, Warsaw (catalogue)

1985
*Remembrance of the First Holy Communion,*
Żuków, Poland
*Wolves, nowolves,* TPSP, Warsaw

## Group Exhibitions

1992
*Documenta IX,* Kassel, Germany (catalogue)
Galerie Isabella Kacprzak, Cologne
*Collection—Documentation—Actuality,*
Museum Sztuki w Łodzi; Musee d'Art
Contemporain et ELAC, Lyon; Galeria Foksal,
Warsaw (catalogue)

*Polnische Avantgarde: 1930–1990,*
Kunstverein, Berlin (catalogue)
*Biennial,* Sydney, Australia (catalogue)

1991
*Kunst, Europa,* Kunstverein, Bonn (catalogue)
Burnett Miller Gallery, Los Angeles
*Metropolis,* Martin Gropius Bau, Berlin
(catalogue)
*Le monde critique,* Kunstverein, Hamburg
(catalogue)
*Europe Unknown,* Palac Sztuki, Cracow
(catalogue)
*Borealis V,* Kunstmuseum, Pori, Poland
(catalogue)
*Körper und Körper,* Kunstmuseum, Graz,
Austria
*Von Angesicht zu Angesicht,* Stadt Galerie,
Kiel, Germany (catalogue)
*Rosa e Giallo,* Galeria Pieroni, Rome
(video catalogue)

1990
*Aperto,* 44th Venice Biennale, Venice
(catalogue)
Galerie Peter Pakesch, Vienna
*Possible Worlds,* Institute of Contemporary Art/
Serpentine Gallery, London (catalogue)

1989
*Middle Europe,* Artist's Space, New York
(catalogue)
*Dialog,* Kunstmuseum, Düsseldorf; the
Contemporary Art Center, Warsaw (catalogue)

1988
*Sculpture in the Garden,* SARP, Warsaw
(catalogue)
*B.K.K.,* Haag Centrum voor Aktuele Kunst,
Den Haag, The Netherlands (catalogue)
*Polish Realities,* Third Eye Center, Glasgow
(catalogue)

1987
*2nd Biennial of New Art,* Zíelona Góra, Poland
(catalogue)

1986
*Figures and Objects,* Galeria BWA, Puławy, Poland (catalogue)

1986–1989
*Activity in consciousness,* Neue Bieriemiennost

## Bibliography

Catalogues and Books
Bałka, Mirosław. "For All Saints," catalogue text, Galeria Wielka, Poznań, Poland: 1986.
_____. "Pracownia Dziekanka: 1976–1987," catalogue text, Galeria Dziekanka, Warsaw: 1990.
_____. "Restlessness of Thought," catalogue text, Contemporary Art Center, Warsaw: 1989.
Blase, Christoph. –––, exhibition catalogue, De Appel Foundation, Amsterdam: 1991.
_____, "Le monde critique," *Le monde critique* exhibition catalogue, Kunstverein, Hamburg: 1991.
Blazwick, Iwona. "Interview," *Possible Worlds* exhibition catalogue, Institute of Contemporary Art and Serpentine Gallery, London: 1990.
Bos, Saskia. "Kunst, Europa 1991," *Kunst, Europa* exhibition catalogue, Kunstverein, Bonn: 1991.
Ciesielska, Jolanta. "Sculpture in the Garden," *Sculpture in the Garden* exhibition catalogue, EGIT Foundation, Warsaw: 1988.
*Europe Unknown* exhibition catalogue, Palac Sztuki, Cracow: 1991.
Heynen, Julian. "Skizzen zu einem Vokabular," *bitte* exhibition catalogue, Museum Haus Lange, Krefeld, Germany: 1992.
Hoet, Jan, Denys Zacharopoulos, Bart de Baere, and Pier Luigi Tazzi. *Documenta IX* exhibition catalogue, Kassel: 1992.
Joachimedes, Christoph, and Norman Rosenthal. *Metropolis* exhibition catalogue, Martin Gropius Bau, Berlin: 1991.
Kiliszek, Joanna. "Good God," *Good God* exhibition catalogue, Galeria Dziekanka, Warsaw: 1990.
*Kolekoja Sztuki XX wieku, Muzeum Sztuki w Łodzi* exhibition catalogue, Galeria Zacheta, Warsaw: 1991.

*Muzeum Sztuki w Łodzi: 1931–1992,* "Interview," exhibition catalogue, Muzeum Sztuki w Łodzi, Łódź, Poland: 1992.
Morzuch, Maria. Interview, *Collection — Documentation — Actuality* exhibition catalogue, Museum Sztuki w Łodzi and Musee d'Art Contemporain et ELAC, Lyon: 1992.
_____. "Polish Realities," *Polish Realities* exhibition catalogue, Third Eye Center, Glasgow: 1988.
_____. "River," *River* exhibition catalogue, Galeria Labirynt 2, Lublin, Poland: 1989.
Przywara, Andrzej. "Empty place," *April/My body cannot do everything I ask for* exhibition catalogue, Galeria Foksal, Warsaw: 1991.
_____. "Borealis V," *Borealis V* exhibition catalogue, Kunstmuseum, Pori, Poland: 1991.
_____. "Interview," *Von Angesicht zu Angesicht* exhibition catalogue, Stadt Galerie, Kiel, Germany: 1991.
*Rosa e Giallo,* video catalogue, Galeria Peroni, Rome: 1991.
Rottenberg, Anda. "B.K.K.," *B.K.K.* exhibition catalogue, Haag Centrum voor Actuele Kunst, Den Haag, The Netherlands: 1988.
_____. "Figures and Objects," *Figures and Objects* exhibition catalogue, Galeria BWA, Puławy, Poland: 1986.
_____. "Percepta patris mei servivi semper," *Percepta Patris Mei Servivi Semper* exhibition catalogue, Galeria Pokaz, Warsaw: 1986.
Smith, Valerie. "Metaphysical Visions — Middle Europe," *Middle Europe* exhibition catalogue, Artist's Space, New York: 1989.

Articles
Blase, Christoph. "Again Everything and Everything Again," *Kunst Bulletin* (1990).
_____. "Ausserdem," *Kunst Bulletin* (1990).
_____. "Tranen an Stahlzelt," *Frankfurter Allgemeine Zeitung* (1992).
Ericson, Lars. "Materialen bar historia," *Dagens Nyheter* (Dec., 1991).
Galloway, David. "Metropolis: Crossroads or Cul de Sac" *Art in America* (no. 4, 1991).
Guldemond, Jaap. "Mirosław Bałka," *Forum International* (no. 3, 1991).
Karavagna, Christian. "Mirosław Bałka," *Kunstforum* (1992).

Kiliszek, Joanna. "Drei Polen im dritten Stock," *Neue Bildende Kunst* (1992).

_____. "Mirosław Bałka at Dziekanka Gallery," *Flash Art* (1990).

Morzuch, Maria. "Duration," *Oko i Ucho* (no. 1, 1989).

Nilsson, John Peter. "Den manskliga svettens slutliga materia," interview, *Aftonbladet* (1992).

Pagel, David. "Mirosław Bałka," *Arts Magazine* (no. 2, 1992).

Pietsch, Hans. "London: Europaische Skulptur heute," *ART* (1990).

Przywara, Andrzej. "Mirosław Bałka," interview, *Flash Art* (no. 160, 1991).

Rottenberg, Anda. "Art in many kinds of Asylum," *DU* (no. 2, 1990).

_____. "Draught," *NIKE* (no. 16, 1987).

Sandqvist, Gertrud. "Symboliken Lurar i svettesangarna," *Svenska Dagbladet* (1991).

Schjeldahl, Peter. "The Documenta of the Dog," *Art in America* (no. 1, 1992).

Schlagbeck, Irma. "Polen: Aufbruch aus dem Untergrund," *ART* (no. 1, 1991).

Sleevensz, Bert. "Mirosław Bałka," *Metropolism* (no. 4, 1991).

Smolik, Noemi. "Aspekte der Sculptur," *Kunstforum* (1992).

_____. "Mirosław Bałka," *Artforum* (no. 1, 1992).

Wojciechowski, J. "Mirosław Bałka," *Flash Art* (1990).